IMAGES
of America

CLINTON

A reenactment of the Mississippi College Rifles assembles outside of the President's House in 1910. In April 1861, one hundred and four men from the college and Clinton enlisted to form this unit. During the Civil War, the College Rifles served as Company E of the Mississippi 18th Regiment, which saw action at Bull Run, Chancellorsville, and Gettysburg. Other units of Confederate veterans, such as trustee president W. T. Ratliff's company, continued to gather and keep in contact from year to year, but there were only eight survivors of the College Rifles. (Courtesy of Mississippi College [MC].)

ON THE COVER: Taken at the beginning of the 20th century, this photograph shows generations of the Johnston family posed outside their homestead on West Leake Street. In the buggy are Robert H. Johnston Sr., his sister-in-law Rose McLaurin, and niece Lucy J. McLaurin. On the far left is probably Robert's wife, Katherine M. Rodgers Johnston. Standing on the handrail is Joseph "Joe-Joe" Johnston. Next to the unidentified woman in the hat is Sally Iungherr Johnston, the mother of Robert Johnston Sr. The elder Mrs. Johnston and her husband, Dr. W. H. Johnston, built the Johnston House, which stands today.

IMAGES
of America

CLINTON

Chad Chisholm

ARCADIA
PUBLISHING

Published by Arcadia Publishing
Charleston SC, Chicago IL, Portsmouth NH, San Francisco CA

Printed in the United States of America

Library of Congress Catalog Card Number: 2006930543

For all general information contact Arcadia Publishing at:
Telephone 843-853-2070
Fax 843-853-0044
E-mail sales@arcadiapublishing.com
For customer service and orders:
Toll-Free 1-888-313-2665

Visit us on the Internet at www.arcadiapublishing.com

ACKNOWLEDGMENTS

I want to thank the Clinton Visitor Center staff and its director, Jacque McLemore. Without Jacque, this book might have been impossible. I am grateful to Kristi Robinson and Ann Bryant at the Mississippi College Room, and I appreciate Norman Gough and Dr. Ed McMillan for their foreword. I also want to thank Dr. Walter Howell, former mayor, for proofing and editing these pages.

I am thankful to John H. Fox III, former city attorney, for his assistance with Clinton's early history. I want to thank Robert Wall, former director of Church Relations at Mississippi College. I owe many thanks to Bob and Lyda Gilmore, who provided the cover image and many others. I owe many thanks to Clinton historian Shirley Faucette for her scholarship on Clinton and to Beth Kirkland, who helped retrieve Miss Faucette's pictures of the Thomas family. I am also grateful to Wyatt Waters, Ed McDonald, Debbie Tillman, Diane Newman-Carson, and Jan Nieminen at the chamber of commerce, Charlene McCord at the Arts Council of Clinton, Ryan Kelly, David and Mary Fehr, Mark L. Ridge, and all of the Clinton churches.

I dedicate this book to my family: father Basil, mother Dana, brother Brad, sister Katy, Zac, Kristin, Elizabeth, Billie, Clyde, Dane, Kim, and grandparents Hugh and Joyce Clarke. I also dedicate this book to W. B. and Rachel Chisholm, who could not see it published: where they live, these books are entirely irrelevant.

CONTENTS

FOREWORD

Clinton, or Mount Salus as it was originally called, is steeped in history and folklore. Many lines of copy have been written in books, magazines, and special news articles relating to its past. Clinton was once the camping grounds of the Choctaw tribe. As it approaches the year 2007, the city is expanding in rapid fashion, yet it has managed to maintain an unbreakable relationship with factual Native American connections.

The historic Natchez Trace, stretching from Natchez, Mississippi, to Nashville, Tennessee, was the first roadway through Clinton. It was once known as the Choctaw Trail or Chickasaw Trail. Even today, one can stroll parts of the original trail when they visit the Clinton Nature Center in the heart of the community or view artifacts in the new Clinton Visitor Center.

Early settlers were attracted to Mount Salus (Clinton) because of rich, fertile land and soothing health springs. In fact, the name Mount Salus meant "mountain of health" and was chosen earlier by Gov. Walter Leake for his home in the frontier community.

As you thumb through the pages of this book, you will see photographs that show a major portion of Clinton's heritage. There's an old adage that states, "A picture is worth a thousand words." The author's goal was to tell the story of the community in photographs collected from a cross-section of current and former residents and other sources. This book furnishes you the chance to view the interesting history of one of Mississippi's and the South's best-kept secrets.

Leaf through the pages of this long-overdue documentation of Clinton's past. There is no better way to remember the past than through the means of photography. Study the photographs on each page. Some sights you may never have seen, and some you pass by daily but had no knowledge of their historical significance. You can enjoy this pictorial journey into the past because of the diligence of a young man who devoted many hours researching and interviewing longtime residents of the city.

Although Clinton missed by only one vote becoming the state capital, it has still carved its own segment of Mississippi history in a grandiose way. Clinton has been the home of many distinguished statesmen, educators, authors, and artists, as well as the state's oldest institution of higher learning—Mississippi College.

You will appreciate more the unique and special place called Clinton, Mississippi, after you view these photographs of events, places, and people from its historical past.

—Norman H. Gough Sr.
Edward McMillan, Ph.D.

INTRODUCTION

The present city of Clinton, Mississippi, is directly adjacent to Jackson, the capital of Mississippi. Most Mississippians (as well as some present-day Clintonians) think they know Clinton. Ask a new Clintonian—and anyone, this author included, whose family moved here after 1960, is still new—and he or she will probably quote such statistics as the city's population of 23,347, a sizable urban area for rural Mississippi. Other new Clintonians might ebulliently add that their suburban mecca is the most prominent "bedtime community" within the Jackson metropolitan area, which numbers about 400,000 residents. The new Clintonian who habitually reads the *Wall Street Journal* might focus on the city's economic eminence: Clinton is home to companies such as Delphi Corporations–Packard Electric Systems and a branch office of MCI/SkyTel. Many new Clintonians will mention the city's government-rated Level Five public school system and Mississippi College, Clinton's historic institution of higher learning.

However, beneath the surface of commercial sprawl and urban flight is a unique and independent history, and Clinton's past coexists with its present. For instance, when the city began construction on Eastside Elementary School, workers unearthed several Choctaw arrowheads. An occasional Civil War minié ball is not an uncommon discovery in a garden or backyard. Clinton's past is alive and reveals itself to anyone who has patience and a sharp eye.

Clinton was formed in 1823 as Mount Salus (meaning "mountain of health" in Latin), and in 1828, the citizens changed the name of their teeming village to Clinton after Gov. Dewitt Clinton of New York, the man famous for pushing the construction of the Hudson Canal. The city was founded by Walter Leake, the third governor of Mississippi, who in 1823 supposedly built the first brick home in Hinds County.

However, none of these interesting facts means for a moment that the Clinton area was entirely tame in 1823. Clinton's effulgent future in the fields of economics, academics, and community would have seemed a mere dream to Mrs. Priscilla Thomas Patten, whose parents, Daniel and Polly Thomas, moved their family to a homestead west of Clinton in 1830. About 60 years later, Mrs. Patten retold her experience:

> The country was new, very few settlers. We went into the woods, not a stick cut. Ma and us three children slept in the wagon until a rough log cabin was built. . . . The land was full of game and wild animals. Often a herd of deer would run by across the prairie. We gathered wild plums, grapes and haws. Hickory and walnuts were abundant. A company of Indians (Choctaws) were camped in the swamp near us. They lived some distance but came here every fall and winter to get furs. [There were] so many animals. The wolves frightened us very much. They would come up near the house and howl and yell for hours. [The men] built fires out in the yard, blew horns, and fired guns at [the wolves].

Mrs. Patten also recalls an incident during the winter of 1830–1831 when her father hired a young Choctaw man to watch after the family while he traveled:

[The Choctaw man] would kill a deer every day, bringing the hams to my mother. One night it was raining, the wind blowing, [and] the dogs began to act strange. The Indian looked out and said some animal was near. Just then he ran [into the kitchen] to the fire and piled all the wood on and made a big blaze. After a while he looked out and all was quiet. He said it was a panther and [later] we saw the prints of its feet where it [had] climbed up on the chimney.

Eventually the forests were cleared, the wild animals were killed or driven deeper into the woods, the federal government removed the Choctaws from their ancestral lands, and soon this frontier image of Clinton faded into a dream.

Today Clinton is a satellite of Jackson, but in 1829, Clinton fell one vote short of becoming the state's capital. In May 1863, Clinton was occupied by Union troops under the command of Gen. Ulysses S. Grant, who was on his way to Vicksburg. Because of its proximity to this city, Clinton was in the backyard of an active theater of warfare, and Clinton women such as Polly Thomas and her sister Nancy had to put on a brave countenance to face Union occupation while their sons were fighting and dying in Confederate units such as the Mississippi College Rifles.

During Reconstruction, inspiring individuals such as Sarah Dickey came to Clinton to educate the freed slaves. Dickey opened Mount Hermon Female Seminary in 1871 near where Sumner Hill is today. Miss Dickey ran Mount Hermon for 28 years and enrolled up to 100 students per session. However, Reconstruction was also a time of infamy and tragedy, and Clinton had its share of both. In September 1875, a state election year that was a hotbed of political unrest across Mississippi, the Clinton Riot occurred north of downtown during a political rally of about 3,000 people. About 50 people were killed in the riot, most of them black Republicans.

In the early years, Clinton was home to two institutions of higher learning: Mississippi College and Central Female Institute (later Hillman College). By 1850, both colleges were affiliated with the Baptist Church, and having two colleges in the same town earned Clinton the title of Mississippi's "seat of learning." However, after the Civil War, both colleges were on the verge of closing and might have succumbed were it not for the leadership of Charles Hillman, who served for a time as president of both colleges. From the late 19th century until World War II, Clinton's colleges dominated its social, economic, and political life.

During World War II, Clinton had a military importance as a housing place for German prisoners of war captured in the North African desert. Most of the POWs came from Erwin Rommel's Afrika Korps. Camp Clinton was a detaining place for some of the most important German POWs, holding 35 of the 40 German generals captured by Allied forces. After World War II, Clinton enjoyed new growth and development, and Mississippi College grew, with more students enrolling on the G.I. Bill. Many who came to Clinton to work at the POW camp or to attend Mississippi College after the war became Clintonians.

Images of America: *Clinton* captures a piece of each era of Clinton's past. Clinton's past is a chronicle that belongs to Clintonians, new and old alike.

One

BEGINNINGS

As the reader can ascertain from Mrs. Patton's account in the Introduction, Clinton began as a common frontier town. However, in 1829, Clinton was about to acquire its own railroad, was one of the largest cotton centers in Mississippi, and was one vote from becoming the state capital. Clinton's rise was hardly coincidence. Before Clinton even resembled a settlement, the area was blessed with a resource: an abundance of springwater. Robinson Spring was a haven for exhausted travelers on the Natchez Trace. Several travelers saw this salubrious frontier environment as an ideal place to settle. Some of Clinton's first settlers were ambitious, visionary men such as Walter Leake and Isaac Caldwell, who wanted to mold Clinton into a new Southern showpiece.

The original Natchez Trace was an old Native American trail and was opened by the federal government in 1802, stretching from Natchez, Mississippi, to Nashville, Tennessee, a distance of about 450 miles. Before the era of the steamboat, the trace was important as an overland road for travelers and flatboatmen making the return trip from New Orleans. (Courtesy of Basil Chisholm.)

Its abundance of fresh springwater naturally made the Clinton area a popular resting place for travelers on the Natchez Trace, and it was here on the old trace where Clinton's first settlement, the trading post of Mount Dexter, was located. Today the Natchez Trace is a popular route for leisure motorists, but parts of the old trace still exist. This segment of the old trace is located in the Clinton Community Nature Center. (Courtesy of Basil Chisholm.)

In the early days of the Mississippi Territory (modern-day Mississippi and Alabama), every piece of land north and west of Natchez was occupied almost exclusively by Native American tribes such as the Choctaw and Chickasaw. This Mississippi Territory map marks the Native American lands prior to settlement: the Choctaw lands in the central region and Chickasaw lands in the north. Before 1823, the land that was to become Clinton was at the southern edge of the Choctaw lands. The treaties of Doak Stand (1820) and Dancing Rabbit Creek (1830) opened these lands for settlement. (Courtesy of Mississippi Department of Archives and History [MDAH].)

Robinson Spring is named for Col. Raymond Robinson, a veteran of the Revolutionary War and the War of 1812, who owned this land in the 1830s. In 1802, government officials surveying the Choctaw lands discovered five or six such springs where crystal waters flowed in abundance. For thousands of years, the springs provided fresh water for the forefathers of the Choctaws and countless animals. The springs were a popular resting place for travelers on the Natchez Trace, and in later years, resorts were built and families settled in the area known as Mount Salus. Robinson Spring is located south of the Mississippi College campus. (Courtesy of MC.)

Clintonians continued to gather water from Robinson Spring as late as 1925, when the city installed its modern system. Robinson Spring was neglected for years, but in the late 1980s, Joy Nobles, wife of Mississippi College president Dr. Lewis Nobles, led a major effort to restore the historical site. In this photograph, three men attempt to pump silt and sand from the spring. (Courtesy of MC.)

The first outpost in the Clinton area was established in 1805 at the junction of the Natchez Trace and Old Vicksburg Road. Mount Dexter was the name of the settlement, which was a Native American outpost operated by Robert H. Bell. Fifty years later, Central Mississippi would be known for its antebellum houses and large plantations. However, in the early years of the Mississippi Territory, frontier cabins such as this would have been the most common residences near Mount Dexter and on the Natchez Trace. (Courtesy of Robert Wall.)

Cowles Mead (pronounced "Coals") was born in Bedford County, Virginia, in 1776 and came to Mississippi in 1806 as the new territorial secretary of the Mississippi Territory, appointed by President Jefferson. Mead was politically ambitious and did not have to wait long to make a name for himself. During the absence of territorial governor Robert Williams, Mead was named acting governor of the territory for a six-month period. During his active governorship, Mead was faced with a national crisis when on January 10, 1807, Aaron Burr, former vice president and shooter of Alexander Hamilton, landed at Bruinsburg on the Mississippi River with a group of followers. Fearing that Burr wanted to overthrow the territorial government, Mead immediately took precautions to arrest Burr. His decisive actions earned him the nickname General Mead, which he would always be known by in later years. Mead's colleagues in state politics praised Mead as an eloquent speaker, but these talents did little to improve Mead's political fortunes. He died in 1844. (Courtesy of MDAH.)

General Mead married Mary Magruder of Clinton, who was his third wife, in 1834. After Mead lost his bid for governor, the general returned to private life and built Greenwood, his plantation in Clinton. Greenwood was one of six Clinton plantation houses to be burned in 1863 by Union troops. Today this family cemetery near the Natchez Trace is all that remains. However, there are several written accounts of Greenwood. Charles Hillman Brough gives us a description of life at the Mead home: "Greenwood stood in a lawn of fifty acres; its broad carriage way was frescoed with rows of magnolias, pines and live oaks; its lawn was carpeted with a rich sward of Bermuda grass, which General Mead is said to have introduced into the United States . . . [and in] his garden beneath an aged cedar tree was the wide garden seat where General Mead drank his after dinner coffee and discussed the affairs of State with distinguished visitors." Greenwood Cemetery, years ago, was overgrown with underbrush and weeds. Today it is restored as a stop for motorists on the Natchez Trace. (Courtesy of Debbie Tillman.)

Walter Leake was born in Albemarle County, Virginia, in 1762, and at a young age, he ran away from home to join his father, Capt. Mask Leake, in the fight for American independence. After the war, Leake served as a state representative in the Virginia House of Burgesses. Unlike Cowles Mead, Leake had a niche for political success and was by all accounts politically shrewd and able. Leake was appointed judge of the Mississippi Territory in 1807 by President Jefferson; Leake served as one of Mississippi's first two U.S. senators, and in 1821, he was elected Mississippi's third governor. In 1823, Leake became the first governor to be elected to a second term, but in 1825, he became ill and died at his home in Mount Salus before completing his term in office. (Courtesy of MDAH.)

Leake

To The House of Representatives

In conformity with the Resolution of the House of Representatives of the instant requesting information in relation to the "amount of moneys received by the several Indian Agents within the limits of this State for taking up Runaway Slaves and the application of the same". I have the honor to communicate the report made to me by the Secretary of State on that subject

Walter Leake

Jackson Jany the 5th 1824

Gov. Walter Leake wrote this letter, in his own hand, to the Mississippi House of Representatives on January 5, 1824. The letter is brief—more of a memo or item list of things Governor Leake had planned to address before the legislature—but the references "Indian agents within the limits of this state for taking up of Runaway Slaves" indicates the arising political concern of Leake's day. (Courtesy of MDAH.)

In 1823, Governor Leake bought two half-sections of ceded Choctaw land next to Robinson Spring and built this Federalist-style mansion he called Mount Salus, which is Latin for "mountain of health." The antebellum house was completed in March 1825. Supposedly Mount Salus was the first brick home in Hinds County, and the bricks themselves were made on the estate by Leake's slaves. Eight months later, Leake died in his new home. (Courtesy of Bob and Lyda Gilmore.)

The Leake house survived the Civil War but was destroyed by a fire in the 1920s. The Ashford House is a 1940s replica of Mount Salus built by Martha L. J. Ashford (her maiden name was Martha Leake Johnston, and she was a direct descendant of Walter Leake) in the Federalist design of the Leake house with columns and a gable constructed at the front center. The foundations of the original town of Mount Salus (Clinton) were centered on these grounds. (Courtesy of Robert Wall.)

This early map of the town of Clinton reveals plots of land owned by some of Clinton's earliest citizens, such as Gidion Fitz and Isaac Caldwell, and streets such as Comfort and Caldwell Streets that have disappeared. To the south is five acres marked for Mississippi College, which at this time was known as Hampstead Academy. West and north of the academy, near the center of town, is a small plot called "public square," which was set aside as the possible site for a new state capital building. (Courtesy of MDAH.)

This forgotten family cemetery south of Mississippi College was rediscovered in the 1980s and contains the remains of some of Clinton's oldest citizens, such as Raymond Robinson, his wife, Anna, daughter Elizabeth, and son-in-law Isaac Caldwell. Colonel Robinson owned property in and around Clinton in the 1830s, including a hotel and spa in the town. Robinson Spring and the town of Raymond are named for him. Over the years, Robinson Cemetery was forgotten, lost, and rediscovered when developers were surveying lands south of Highway 80. Robinson Cemetery was taken down and the graves were disinterred and moved to the Clinton cemetery on College Street. (Courtesy of Walter Howell.)

This marker confirms the occupants of the forgotten Robinson Cemetery. Years ago, a local farmer removed the marker to stop erosion in a gully nearby. The farmer was "persuaded" to return the marker to the cemetery. The return of the marker and the discovery of the cemetery are gratifying for Clinton antiquarians. However, it is a reminder of the tragedies suffered by the Robinson family. Judge Isaac Caldwell was killed in a duel with Col. Samuel Gwin in 1835 after state senator George Poindexter, Caldwell's law partner and a candidate for U.S. senator, was defeated by Robert. J. Walker, who had been supported by the Gwin brothers. After Judge Caldwell's death, his wife, Elizabeth, remarried a New Yorker known only as Dr. Kearney. Elizabeth's second marriage ended in murder when Kearney shot her with a small pistol at close range. After the murder, Kearney disappeared, and Colonel Robinson, grief-stricken for his daughter, buried her here and chose to engrave the name Elizabeth Caldwell, her married name with Judge Caldwell, on the marker. (Courtesy of Walter Howell.)

This letter is a challenge from Robert Garland, a Vicksburg attorney, to Judge Caldwell on October 10, 1827. Governor Leake had previously tried to outlaw dueling, but the practice remained an acceptable manner for men to settle disputes. The complaint in the letter is unspecified, except that it has something to do with Garland's friend Dr. Newell, and that another of Garland's friends, Major Perkins, would make all the arrangements. While the cause and outcome of the Garland-Caldwell quarrel are unknown, it does imply that Judge Caldwell had an inclination for settling disputes on the field of honor, and since he was a veteran of the War of 1812, it is certain that Caldwell was not afraid of death. In 1829, Judge Caldwell wanted Clinton to be the capital of Mississippi, and he felt betrayed when John B. Peyton of Raymond, the Hinds County representative who had been supported by many Clintonians, cast his deciding vote for Jackson. Judge Caldwell and Major Peyton fought a duel, but both men emerged unharmed. However, in 1835, on the same grounds, Caldwell fought a duel with Samuel Gwin, another Clintonian, in the same area off the Raymond Road. After 40 paces, the duelers turned, fired, and fell mortally wounded. Judge Caldwell died within two hours; Colonel Gwin died a year later from a wound to his lungs. The Garland duel, if it occurred, would have pushed Caldwell's known duels to three. (Courtesy of MDAH.)

Andrew Thomas was born in 1797 in North Carolina but moved to Mississippi early and built Sunnyside Plantation west of Clinton, near what is now Norrell Road. Sunnyside was surrounded by 6,250 acres. Andrew Thomas married Nancy Beauchamp in 1823, and together they had several children, including Carrie, Mat, Mary Jane, Billy, Cuddy, and Baldwin. In his left hand, Thomas is holding what appears to be his walking stick. The stick is owned today by his descendant John H. Fox III, who claims that Thomas had it made heavy in case he was forced into an altercation in town or around the plantation. He died in January 1877, four months shy of his 80th birthday, outliving the sons he lost in the Civil War. (Courtesy of Shirley Faucette.)

Anne "Nancy" Beauchamp (pronounced "bee-chum") was born in 1798 in Milledgeville, Georgia, and married Andrew Thomas in 1823. Years after the war, Mrs. Thomas told a story to later generations of Clintonians of a Union raid in early 1864. On this particular day, Nancy Thomas received an unexpected visitor at Sunnyside: Gen. William T. Sherman himself. According to Mrs. Thomas, General Sherman rode to the house and politely asked for coffee. Mrs. Thomas ordered her maid—probably a house slave known only as "Alice"—to bring a "cup of coffee," and Alice quickly returned with coffee in a tin cup. Mrs. Thomas, always a paragon of hospitality—even towards a notorious Union general—was perturbed and asked the maid why she had not brought General Sherman a cup and a saucer. Alice's response was to say right in front of General Sherman, "Lord, mistress, he'd steal it. You know them Yankees done took most all we alls cups and saucers. We bound to keep some!" According to Mrs. Thomas, Sherman said nothing but drank his coffee with a "frowning brow." Mrs. Thomas died in 1875. (Courtesy of Shirley Faucette.)

Mary "Polly" Beauchamp was Nancy Beauchamp's sister, younger by two and a half years. Polly became Andrew Thomas's sister-in-law twice over when she married Daniel Thomas, Andrew's brother. Polly Thomas had four sons who served in the Confederate army; one son, Jonathan Greene Thomas, was killed at the Battle of Harrisburg (near Tupelo) in 1864. Despite the loss of Jonathan, Polly Thomas remained loyal to the Southern cause and spent her evenings knitting socks for Confederate soldiers on the front lines. She died in 1878. (Courtesy of Shirley Faucette.)

Caroline "Carrie" Thomas was the daughter of Andrew and Nancy Thomas. Carrie married a man named Hedges. Andrew Thomas built for the young married couple a home near Sunnyside named Sans Souci, which in French means "without concern" or "carefree." (Courtesy of Shirley Faucette.)

Mary Jane Thomas was the daughter of Andrew and Nancy Thomas. In her portrait, the white gown contrasts with a red sash around her waist. Victorians were fond of symbolism, so perhaps the red and white indicates that Mary Jane was a pure yet fiery Southern belle. The red sash could also indicate that Mary Jane was in love when she sat for the portrait, which is possible because she soon married James Criddle. The red and white colors could also be entirely incidental because, as her direct descendant John H. Fox III points out, there were plenty of "headhunters" in the early days. Headhunters were artists who peddled "headless" portraits across Mississippi and would paint a face on the body for a small fee. Mary Jane Thomas (later Criddle) was one of the four Clinton women who made the flag for the Mississippi College Rifles. (Courtesy of Shirley Faucette.)

Andrew Thomas built this house on his vast estate (located near present-day Norrell Road) around 1845 for his daughter, Caroline Thomas Criddle, and her husband, James A. Criddle. Tanglewood was one of several houses that Andrew Thomas built for his married daughters on his Sunnyside estate. Before the war, Mary Jane Criddle was widowed with two children. After the war, Mary Jane's daughter Caroline T. Criddle married Capt. William Lewis, a war hero and one of the eight survivors of the Mississippi College Rifles, and the couple moved the location of Tanglewood to 301 Jefferson Street, where it now sits across from city hall. In 1922, Carrie L. C. Fox, daughter of Captain and Mrs. Lewis, and her husband, John H. Fox, bought the house and lived until their deaths. Today Tanglewood is the home of Clinton historian Shirley Faucette, who is the granddaughter of Carrie and John H. Fox. Tanglewood's ceilings are 14 feet high, and the house rests on original cypress sills. (Courtesy of Robert Wall.)

Calvin "Cuddy" Luther Thomas poses for this photograph on the eve of the Civil War, shortly before he enlisted in the Mississippi College Rifles—later Company E in the 18th Mississippi Regiment Infantry—as a private. Cuddy Thomas was soon elected first lieutenant of the company in early 1861 but resigned in November of that year for unknown reasons and joined a Mississippi cavalry unit. It is believed that Cuddy Thomas was killed in battle near Tupelo in 1864. It is believed that Cuddy died with his cousin, Jonathan. (Courtesy of Shirley Faucette.)

Baldwin B. Thomas was the son of Andrew and Nancy Thomas. Baldwin, unlike his cousins and brothers, did not serve with the College Rifles but at age 29 joined the Raymond Fencibles, which later became Company C of the 12th Mississippi Regiment Infantry. Though he was badly wounded, Baldwin was one of the few Thomas men to survive the Civil War and start a family. Baldwin did not live long after the war. He died in 1869 from the injuries he received. (Courtesy of Shirley Faucette.)

Martha "Mat" Thomas was Baldwin's sister. She married a man named England, and Andrew Thomas built for the couple a house called Oakhurst on his own land. In March 1865, Baldwin married his first cousin, Harriet Elizabeth "Bettie" Beauchamp, and they had one child, a daughter, Bessie Warren Thomas. After Baldwin's death, Harriet remarried and for some reason was unable to raise Bessie, so Bessie was raised by her aunt Mat. (Courtesy of Shirley Faucette.)

Joseph Narbonne (left) and William B. Thomas (right) pose for this picture before the outbreak of the Civil War. Unlike his Thomas cousins, Billy and Cuddy, William chose to serve with Narbonne in the Raymond Fencibles, which later became Company C of the 12th Mississippi Regiment Infantry. (Courtesy of Shirley Faucette.)

Andrew Thomas II poses here in his Mississippi College Rifles uniform. The college militia later became Company E of the 18th Mississippi Regiment. (Courtesy of Shirley Faucette.)

Pvt. Jonathan Greene Thomas (left) and two cousins pose for this photograph in the uniforms of Confederate cavalry. These men served under the command of Gen. Nathan Bedford Forrest. After the Battle of Harrisburg (near Tupelo) on July 14–15, 1864, where both he and his cousin Calvin Thomas fought, Jonathan Thomas was never heard from again. (Courtesy of Shirley Faucette.)

Sgt. William Hampton Thomas (left) is pictured with William Lewis (right) of the Mississippi College Rifles. In the course of the war, William Lewis would be promoted to captain, and after surviving many encounters with Union troops, he would come home to Clinton, settle down, and marry William Thomas's niece, Caroline Thomas Criddle. William died at the Battle of Frazier's Farm in Virginia in 1862. (Courtesy of Shirley Faucette.)

Joseph Buckles was born in Louisiana in 1840 and was a ministry student at Mississippi College at the beginning of the Civil War. In 1861, Buckles joined the Mississippi College Rifles and was quickly elected second lieutenant of the company. Of the 104 men in the College Rifles, Buckles was among the eight survivors. After the war, Buckles returned to the ministry and became a reverend of a Baptist church in Philadelphia, Mississippi. (Courtesy of MC.)

The photograph of this unidentified officer in the Mississippi College Rifles was taken at a muster at Grenada, Mississippi, in 1861. Speculatively, the officer could be either 3rd Lt. J. H. York or Orderly Sgt. Mike Carney. (Courtesy of MC.)

Confederate generals Joseph E. Johnson and John C. Pemberton had chosen Clinton as a rendezvous point to combine their forces and crush Union general Ulysses S. Grant. However, General Grant intercepted the Confederate plans and moved his army rapidly into Clinton. This sketch depicts the arrival of Gen. James B. McPherson's 17th Union Corps into the city. Obviously the Union artist exaggerated the size of Clinton's hills to excite his Northern audience. The arrival of McPherson's force meant that it would be difficult for the forces of Pemberton and Johnson to unite, and Pemberton's troops were forced to face Grant's aggressive onslaught on their own. (Courtesy of First Baptist Church [FBC].)

Clinton historians believe the Ritchey House served as General Sherman's headquarters for a time in 1863 during the Vicksburg campaign. In 1934, this house was demolished in order to clear the lot for the new Clinton City Hall. As it was being torn down, Dr. J. R. Hitt found a brick that was dated 1830. According to an old Clinton map, this house was once the home of a Mrs. Ritchey. (Courtesy of Clinton Visitor Center [CVC].)

Finished in 1861, the Old Chapel was the meeting place of Clinton Baptist Church until 1923. During the Vicksburg campaign, Gen. Ulysses S. Grant used the upper levels of the chapel as a makeshift hospital; the bottom level was used to stable Union horses. The chapel was later renamed Provine Chapel in honor of Dr. J. W. Provine (who served 1911–1932), one of Mississippi College's most indispensable administrators. In later years, the massive belfry was removed from the chapel. (Courtesy of MC.)

While very few members of the Mississippi College Rifles lived to return home, other units were more fortunate and held frequent reunions. W. T. Ratliff, president of the board of trustees at Mississippi College for more than 40 years, poses here with members of his old Confederate regiment at the turn of the century. The old men here wear their medals on their chests and are still proud and inseparable. (Courtesy of MC.)

Built in 1833, the Cedars could be the oldest existing house in Clinton. The original builders were Minerva Fitz Morgan and Jacob B. Morgan, and the house passed through several owners until it was bought in 1859 by Dr. Emile Menger and his wife, who gave it the name Cedar Grove. During the Civil War, the house was in the direct path of Union troops, but the Mengers somehow managed to save their house from the destruction of the Civil War. In 1903, the Menger family sold Cedar Oaks to Prof. Patrick Henry Eager, and his wife shortened its name to the Cedars. In 1976, the Cedars was owned by Dr. and Mrs. James Currey, both Mississippi College professors. During the 1976 presidential election, candidate Jimmy Carter made a visit to the Cedars and spoke to many Clintonians. (Courtesy of Robert Wall.)

The Clinton Cemetery is the oldest in the city. The earliest burial date recorded in the cemetery is 1806, which predates the arrival of Walter Leake, the existence of Mount Salus, and the statehood of Mississippi. Some of the oldest family names in Clinton, such as McRaven, Hillman, Comfort, Menger, and Criddle, can be found here. Today the cemetery is owned by the Clinton Cemetery Association and is administrated by a board of directors. (Courtesy of Robert Wall.)

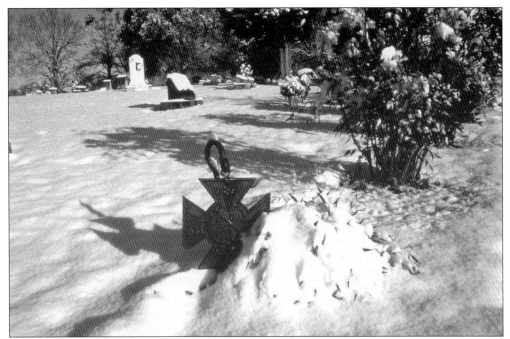

On first glance, this snowy marker appears to be a German Iron Cross, but engraved in the center of the marker is the military flag of the Confederate States. This numinous marker was placed in the Clinton Cemetery by the United Daughters of the Confederacy. (Courtesy of Robert Wall.)

These snowy graves of Confederate soldiers are representative of the 63 total soldiers, both Union and Confederate, who served in the Civil War and are buried in the Clinton Cemetery. Most of the soldiers who lie here in the Clinton Cemetery were killed in General Grant's 1863 Vicksburg campaign. Veterans of the Spanish-American War, World War I, World War II, the Korean War, and the Vietnam War are also buried here in the Confederate lot. (Courtesy of Robert Wall.)

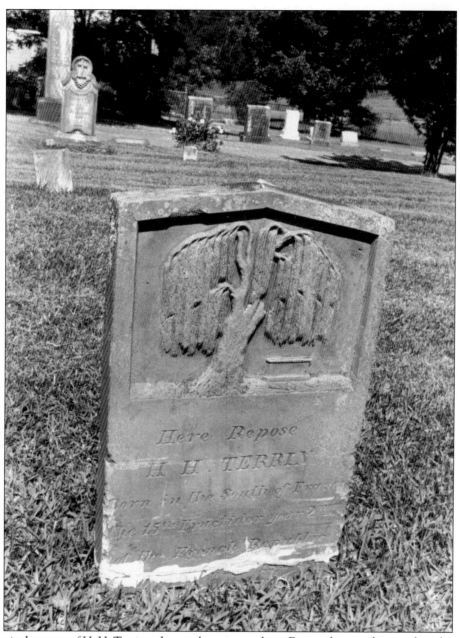

Here is the grave of H. H. Terrin, who was born in southern France during what was later known as the Reign of Terror under Robespierre. Regardless of the conditions of Terrin's birth, either he or his descendants were apparently intrigued with this historical coincidence, because his marker lists the date of birth as the "15th [of] Fructidor[,] year 2nd of the French Republic." Fructidor was the 12th month of the French Revolutionary calendar, which is preceded by the more well-known month of Thermidor, and begins on August 18 or 19 and ends on September 16 or 17. The name "Fructidor" comes from the Latin word *fructus* for "fruits," and most of the days in Fructidor are named for fruits such as Citron (lemon). However, Truite, which is the 15th day of Fructidor, means "trout." Engraved on the headstone is the Liberty Tree, which was a popular icon during the era of the French Republic. (Courtesy of MC.)

In April 1857, a procession of the new Clinton chapter of the Odd Fellows came to a clearing in the forest outside of town and, in a mysterious ceremony, consecrated these grounds as "Odd Fellows Rest." Little is known about the Clinton Order of Odd Fellows, but on some of the gravestones is the insignia of three links of chain symbolizing the order's three principles of Friendship, Love, and Truth. Odd Fellows Rest was once part of the Leake estate. The Clinton order was disbanded long ago, but Odd Fellows Rest was kept up for years by Mrs. Emma Fox Faucette. Behind Odd Fellows Rest, in the background of the picture, is Dayspring Community Church. (Courtesy of MC.)

The Oaks was located near Northside Drive in Clinton. Built around 1850, this Italianate-style home was owned by W. M. Minton about the time of the Civil War. The house survived the Civil War but was destroyed sometime in the early 20th century. This picture was taken around 1906–1907. (Courtesy of MDAH.)

Taken sometime in the early 1900s, this photograph shows a view of Jefferson Street from the college facing downtown Clinton. Although there is a horse-drawn carriage in the center of the photograph, one can easily see that Jefferson Street is already becoming more modern. Clearly visible in this scene are the power poles and electric lines. At the time, glass insulators were used to support the wires. (Courtesy of MDAH.)

Life goes on in Clinton a generation after the Civil War. This picture is obviously a photograph of a Clinton drugstore, but the impressionistic shroud that surrounds these figures suggests that an artist used his or her hand to reinforce this photograph when its images and dark colors began to fade. Below is a picture of the same drugstore some years later, in the early springtime. To the left of the store is a Ford Model T that symbolizes the changing of the nature of the American South from an agrarian culture to one based on automation and technology. (Courtesy of CVC.)

June 1910

The arrival of the train here at the Clinton Depot recalls the grand old age of the railroad. When the Clinton and Vicksburg Railroad Company—which later became the Alabama and Vicksburg line—was chartered in 1831 to build a line connecting the two burgeoning towns, it was the second in Mississippi. On the day the first train arrived full of passengers from Vicksburg, Clinton hosted a great barbeque to celebrate the railroad. That evening, there was a ball at the Galt House, where prominent citizens from Vicksburg arrived to celebrate the arrival of the railroad with their Clintonian partners. However, the regale was abruptly truncated when a tornado swept across Hinds County, tearing up some of the new rails for miles. Several wagons and carriages had to be borrowed to return the train passengers to Vicksburg, but the tornado was merely a temporary setback to Clinton's progress. The Clinton Riot of 1875 occurred near the depot area. (Courtesy of Robert Wall.)

John Henry Fox (left), the longtime railroad agent in Clinton, and a man known as Mr. West, the longtime telegraph operator, pose on the platform on the Clinton Depot as it existed around 1900. Behind the two men are three black men watching the photograph being taken. On the front of the building, a sign reads "Meridian 105 miles" and "Vicksburg 34 miles." In Clinton, there were four different depot buildings; this one is probably the second. (Courtesy of Robert Wall.)

John H. Fox (right) and Mr. West stand outside a newer, larger Clinton depot around 1910. From 1830 to 1920, the railroad was the lifeline of transportation for Clinton, and not just for Clintonians. Imagine this building crowded with students from Mississippi College and Hillman College at the end of the fall semester—young men and women trying to purchase a ticket so they could celebrate Christmas with their families. (Courtesy of John Fox III.)

Carrie L. Criddle Fox, John Henry Fox Sr., and their daughter, Emma Shirley Fox, pose for this picture around 1900. Carrie Fox was a descendant of Mary Jane Thomas, who married John Criddle. John H. Fox was originally from Rankin County but moved to Clinton, were he worked as the railroad agent for the Alabama and Vicksburg line. Later Carrie and John would add another child, John H. Fox II (left). (Courtesy of Shirley Faucette.)

Emma Shirley Fox was the first child and only daughter of John H. Fox Sr. and Carrie L. Criddle Fox, a descendant of Mary Jane Thomas. Emma married Fletcher F. Faucette, an Arkansas man, and is the mother of Shirley Faucette, the longtime town historian of Clinton, Mississippi. (Courtesy of Shirley Faucette.)

John H. Fox Jr. was the second child and only son of John H. Fox Sr. and Carrie L. Criddle Fox. This John Fox left Clinton behind for Oxford to attend the University of Mississippi; later he became an Ole Miss law professor. After a long career as a lawyer and law professor, John Fox joined the U.S. Navy at age 40 at the onset of World War II and eventually rose to the rank of full commander. (Courtesy of John Fox III.)

Three generations of the Fox family gather for this photograph. From left to right are (seated on the couch) Carrie L. Criddle Fox, granddaughter Marjorie, grandson John Fox III, and John Fox Sr.; (standing) John H. Fox II and wife Marjorie Gibbons Fox. If the elder Mr. and Mrs. Fox appear to be scowling, it is because, according to John Fox III, his sister Marjorie had trimmed off all of his curls before the picture! John Fox III followed his father into the law profession and became city attorney for Clinton. (Courtesy of John Fox III.)

Currently the Clinton Hardware store, this building was once the town livery stable, owned by Capt. W. H. Lewis, Civil War veteran and hero of the Mississippi College Rifles. Later the old livery stable was run by Fletcher Faucette, who married Emma S. Fox, Captain Lewis's direct descendant. (Courtesy of Robert Wall.)

Menger Grocery Co.
Dealers in Everything
Clinton, Miss.

The Oldest Firm in Town
The Only Firm who Mark Their Goods in Plain Figures
We Have One Price Only
Your Child Can Buy From us as Cheaply as' Yourself

The statements on this Menger Grocery advertisement—"The only firm who mark their goods in plain figures" and "Your child can buy from us as cheaply as yourself"—indicate that shopping in Clinton at one time was a more mercurial process. The Old North State store (below) was one of Menger's competitors. Beneath the Old North State sign, there are indications that this wooden building was once a pharmacy. (Courtesy of MC and CVC.)

"Uncle Bob's Store" Clinton, Mississippi — marjane '85

Clintonians at the beginning of the 20th century referred to this building as "Uncle Bob Whitaker's drug store," but the original owner and purpose for this antebellum structure are uncertain. The building was at one time a two-story house with three offices on the south end of the building, a shiny staircase in the middle of the east side of the building, and a wall on the south side that separated three offices from the rest of the building. Around 1920, the building was bought by Courtenay Cabell, who used it as a watch repair and gun shop. It was Mr. Cabell who lowered the height of the building by 15 feet and added a tin roof. (Courtesy of FBC.)

Violet Banks was given this descriptive name because of the violets that grew over the banks in front of the house. Violet Banks was probably built in the early 1840s by Harriet Whiting Dunton, a widow, whose name appears on the old Clinton maps as the owner. The home was bought by Dr. E. B. Poole and later bought by Dr. W. D. Potter, who also took over Dr. Poole's medical practice. In 1955, Dr. Hollis Todd and his wife bought Violet Banks from Dr. Potter. The Todds were responsible for restoring and modernizing Violet Banks by removing the balconies and adding brick. (Courtesy of Robert Wall.)

Taken at the beginning of the 20th century, this photograph shows generations of the Johnston family posed outside their homestead on Leake Street. In the buggy are Robert H. Johnston Sr., his sister-in-law Rose McLaurin, and niece Lucy J. McLaurin. On the far left is probably Robert's wife, Katherine M. Rodgers Johnston. Standing on the handrail is Joseph "Joe-Joe" Johnston. Next to the unidentified woman in the hat is the mother of Robert Johnston Sr., Sally Iungherr Johnston. The elder Mrs. Johnston and her husband, Dr. W. H. Johnston, built the Johnston House, which stands today. The family photograph below was taken on the same day. (Courtesy of Lyda Gilmore.)

Above is the inside of the Johnston Store. Second from the right is Katherine R. Johnston, who ran the store on West Leake Street. A glass case of stacked cookies, jars of sweets, men's ties, and cans of Maxwell House coffee nostalgically adorn all corners of the glass counter. The advertisement for R. H. Johnston at right indicates that the store sold a little of everything, from men's clothes to Ford auto parts. (Courtesy of Lyda Gilmore and MC.)

Hartwell Taylor Ashford poses here in his Jefferson College uniform in the early 1900s. Jefferson College was at the time the oldest institution of higher learning in Mississippi. Jefferson closed its doors in 1964, and Mississippi College became the oldest college in the state. H. T. Ashford went on to receive his medical degree from the University of Louisville Medical School in 1903 and became the physician at Mississippi College. Dr. Ashford is said to have delivered 1,000 babies and owned one of the first automobiles in Hinds County. (Courtesy of Lyda Gilmore.)

Lida Hooker Ashford was originally from Pocahontas. In 1878, when Lida was three years old, her mother died, and the young girl came to Clinton to be raised by a relative. Lida fell in love with the younger, redheaded Dr. Ashford when he came to Clinton to practice medicine at Mississippi College. (Courtesy of Lyda Gilmore.)

Edith Ashford was the daughter of Dr. H. T. and Lida H. Ashford. Edith attended Hillman College, but when her mother and father were injured in a car accident, Edith was forced to leave school and tend to her parents. Edith married Robert H. Johnston II, son of the store owner. Edith was an excellent seamstress, and she made dresses for the dolls sold at the store. (Courtesy of Lyda Gilmore.)

Robert H. Johnston II here is two years old, the son of store owner Robert Johnston Sr. and Katherine R. Johnston. Robert Sr. died early, and Robert Jr., unlike his siblings who left Clinton, stayed and helped his mother run the store. Robert married Edith Ashford, had two daughters, Edith and Lyda, and lived in the Johnston House. In those days, the land surrounding the Johnston House was undeveloped. Daughter Lyda recalls that her father kept cows and chickens on the property. (Courtesy of Lyda Gilmore.)

The Fancy Formal dress shop is presently located in this building, but in the 1930s, it housed the Ratliff Motor Company, owned by Fred and Ed Ratliff, who sold delivery vans. In the 1920s, the Ratliff brothers owned a gas station on Jefferson Street, and one day in 1925 or 1926, they received a visitor from out of town, Charles Lindbergh. At the time, Lindbergh was piloting a two-seater biplane on an airmail route. Lindbergh landed his plane in a pasture owned by Robert Johnston Sr. and walked to the Ratliff station. In return for gasoline (which then was 9 or 10¢ a gallon), Lindbergh offered to give Fred and Ed Ratliff and their friend Allen Ray McEarley a ride in his biplane and offered others a ride for $5. Below, hunters Pettigrew Warren (left) and Fred Ratliff display their catch of mallards and fish. (Courtesy of CVC.)

From 1833 to 1842, Clinton's first banking services would have been associated with the railroad, real estate offices and the lottery. General Mead became the president of the Real Estate Banking Company in Clinton. However, these early forms of banking were often risky. When Real Estate Banking collapsed and customers broached the topic of their lost deposits with General Mead, the old statesman could only say, "See my cashier about the matter, for my mind is on things spiritual now, not on things temporal." The Bank of Clinton was opened around 1906, and P. S. Stovall was its first president. The Bank of Clinton was located on West Leake Street at first, where the Western Auto is in this picture (indicated by the heading "Bank" still visible on the structure), and later on the corner of the block itself. (Courtesy of Robert Wall and MC.)

This little schoolhouse was built around 1900 and was located at the end of West Main Street near Fire Station Number 1 and the water tower. The school's first teachers were Kittie Anderson and Moriah Johnson. Sometime in the late fall or winter, the fifth- and sixth-grade classes and their teacher gather outside the old wooden schoolhouse for their picture (below). In the first row is young John H. Fox II. This was probably one of the last classes to be taught in the wooden schoolhouse. (Courtesy of FBC and John Fox III.)

The brick schoolhouse was built around 1918 at the cost of about $18,000 and was located on College Street where the old Clinton Junior High is today. The brick school had six classrooms, all "scientifically lighted," and at the time of this photograph, it had six teachers and 215 students from a total of 10 grades. Pictured below from left to right are (first row) Lois Myers, F. A. Murphy, and Trughen Bailey; (second row) Jessie Owen, Nelly Magee, Verna Williams, and Principal W. B. Kenna. Both boys and girls are visible in the background, reminding us that the public schools had long been coeducational. The amount of money spent on education was $14.89 per student each month. On average, a teacher received a monthly salary of about $41.32. (Courtesy of MC and FBC.)

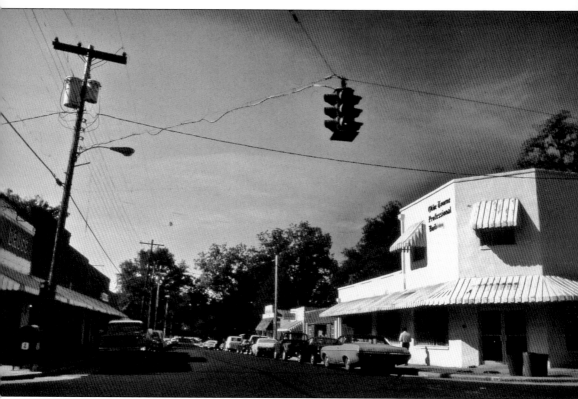

In the 1830s, the center of Clinton was located around West, West Madison, and West Leake Streets. Antebellum Clinton was not a large metropolis, but it was an active, vibrant community. Clinton was the largest cotton center between Meridian and Vicksburg, shipping 20,000 bales each year. There were also two drugstores, a stagecoach line, and "over twenty dry goods stores carrying stocks from $20,000 to $40,000" according to Judge T. J. Wharton. The devastation of the Civil War left the Clinton business district in ruins, but around 1900, it had made a significant comeback, though on a smaller scale than what had been. Here is the intersection of Jefferson and Leake Streets, where the new business district was focused. (Courtesy of Robert Wall.)

Two

A Paragon of Learning and Culture

The history of Clinton can be collected through its institutions, architectures, and monuments; each of these has left its indelible mark on present-day Clinton. Clinton hosts a large amount of historic churches, and each denomination is represented in the community from Greek Orthodox to Southern Baptist, from Roman Catholic to Pentecostal. Clinton is also home to Mississippi's oldest institution of higher learning, Mississippi College, which is today a modern, 21st-century college, a mixture of past and present. Most Mississippians know of Mississippi College, but few are aware of its longtime counterpart, Hillman College, the women's college that was located in the heart of Clinton itself and was also affiliated with the Baptist Church. Most Clintonians are unaware of the existence of Mount Hermon Female Seminary and its dauntless founder, Sarah Dickey.

Here is a sketch of Mount Salus Presbyterian Church, the first to be built in Clinton. Mount Salus was established as a mission in 1826, and two years later, this missionary entered the Presbytery, making it the first Presbyterian church in Hinds County. In 1850, when the Baptist congregation first arrived in Clinton, the Presbyterians generously offered them the use of their church until 1861, when the Baptists began having services in present-day Provine Chapel. After the construction of the chapel, the Baptists used Mount Salus as an academic building for Mississippi College. (Courtesy of FBC.)

This building is known as the old Mount Salus school, which Mississippi College historians speculate was the first building of Hampstead Academy (later Mississippi College). As the Presbyterian congregation began to falter, the fledgling Baptist Academy made use of the building. Perhaps this photograph has captured the remnants of the first church in Clinton. (Courtesy of Robert Wall.)

Rev. Daniel Comfort (1785–1855) was an ordained Presbyterian minister and a former Princeton professor. Comfort came to Clinton in 1827 to serve as the first president of Hampstead Academy (later Mississippi College) when the school was affiliated with the Presbyterian denomination from 1842–1850. Reverend Comfort also served as a minister at Mount Salus. Comfort was an Old Doctrine Presbyterian. A dispute between the New Doctrine and Comfort's own led to deep divisions within Mount Salus and eventually ended the Presbyterian association with Mississippi College, which also marked the decline of Mount Salus Church. (Courtesy of Mount Salus.)

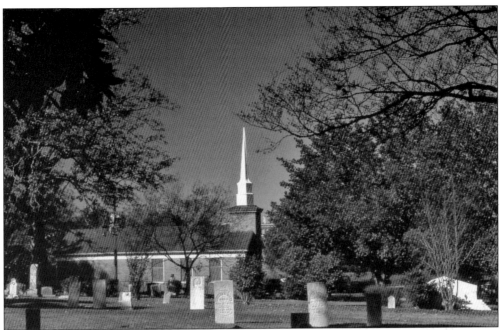

After the Civil War, the dwindling Mount Salus congregation wrote a letter addressed "To the Officers and members of the Baptist Church in Clinton" where they accused the Baptists of being poor stewards of their building by "driving nails into the plastering & seats, cutting, marring, shaking down part of the seats" and other complaints. War and doctrinal controversies had devastated Mount Salus, and after 1887, the church has no recorded minutes. There was no Presbyterian church until 1952, when postwar growth brought new Presbyterians to Clinton. Ironically it was Mrs. R. W. Hall, a member of the Baptist church, who gave the Presbyterians this land adjoining the Clinton Cemetery on 415 East College Street. The building pictured above was constructed in 1955. The steeple was added in the 1980s (right). (Courtesy of Mount Salus and Robert Wall.)

On March 2, 1952, these Presbyterian families met at the old Methodist church on West Main Street for the first assembly of the new Mount Salus Presbyterian Church. Somewhere in the center of the photograph are Emma F. Faucette and her daughter, Clinton historian Shirley Faucette. Below, Mount Salus children celebrate Christmas 1955 in their new building. These photographs of a nascent Mount Salus congregation capture a new chapter of Mount Salus history. However, in 2006, this chapter was closed when the Mount Salus congregation voted to merge with St. Paul Presbyterian in Jackson. Together these congregations plan to build a church in northern Clinton, and Holy Resurrection Orthodox Church has bought the Mount Salus building. To quote the Holy Resurrection's Web site, "Needless to say, icons will come and pews will go." (Courtesy of Mount Salus.)

Holy Savior Catholic Church in Clinton is located at 714 Lindale Street and was founded in 1966. However, the below photograph is evidence of an earlier Catholic congregation somewhere in the Clinton area. A Sunday school class takes a stroll in the woods in early 1900. Several Johnston children are pictured here, who were raised Catholic by parents Robert Sr. and Katherine Johnston. The clothes of these Catholic children indicate that the congregation consisted of every economic range within the community. (Courtesy of Robert Wall and Lyda Gilmore.)

Founded in 1831, the Methodist church is the oldest existing congregation in Clinton and one of the oldest in Central Mississippi. Rev. Thomas Ford became Clinton Methodist Church's first minister, and in 1836, Reverend Ford was able to devote two Sundays a month to preach in Jackson, which then had no Methodist congregation. As a result of Reverend Ford's missionary work, Clinton Methodist Church became a sponsor for what is now Galloway United Methodist Church in Jackson. The Methodist congregation has occupied four different locations since 1831. The church above was constructed in 1925–1926 and was located on 100 West Main Street. The building below was built in 1965 and is today the fellowship hall. (Courtesy of Clinton Methodist Church.)

The Methodist congregation in 1957 gathers to worship. In the first row above are B. E. Martin (far left), who owned College Cleaners in Clinton, and his wife, Maycel Martin (second from left). The couple had a daughter, Jacque Martin (now McLemore), who is currently the director of the Clinton Visitor Center. Before service, the Methodist choir warms up during a final choir practice below. (Courtesy of Clinton Methodist Church.)

The Baptist church in Clinton was founded in 1850. Service for years was held in what is now the Provine Chapel until April 1, 1923, when this structure was completed. Recent growth in the Baptist church has been rapid, and in 1989, the Baptist congregation moved into a new building with a seating capacity of 1,200. The 1923 structure was remodeled and is today used for activities such as recitals, weddings, and youth services for the church. Below is the house on College Street that for years was the College Department of the First Baptist Church of Clinton. (Courtesy of Robert Wall.)

The First Baptist Church of Clinton's choir of seniors prepares to sing praises. Below, the senior members of the First Baptist Church of Clinton eat and socialize in the fellowship hall. (Courtesy of FBC.)

Above is Morrison Heights Baptist Church of Clinton at 201 Morrison Drive. Today Morrison Heights is one of the largest, most established churches in Clinton, and it began on January 5, 1958, when members of the Clinton Baptist Church (presently the First Baptist Church of Clinton) decided to erect a tent (just north of the present church) owned by Hinds County on a lot east of Clinton off what is now Clinton Boulevard. The Clinton Baptists were led by Dr. Gordon Sansing and Ed McDonald, who started the tent as a missionary to serve the community to the east of town. On June 15 of the same year, the thriving mission was organized as a church with a total of 126 charter members. (Courtesy of Robert Wall and MC.)

This father-and-son dinner in late 1958 took place inside the old tent. However, by then the church was already constructing a new building, which was dedicated on the one-year anniversary of the founding of Morrison Heights Baptist Church. (Courtesy of MC.)

Above is an aerial picture of Mississippi College in the 1930s. Next to the present First Baptist Fellowship building is what was the house of the college president. In the bottom center are tennis courts where Nelson Hall is today, and covered in trees is what was once a nine-hole golf course. Founded as Hampstead Academy in 1826, Mississippi College is the state's oldest existing institution of higher learning. The academy began as a Presbyterian institution and was located near the original Mount Salus Church. However, in the late 1840s, the Clinton Presbyterians split over doctrinal controversies and were unable to manage the school. The trustees first asked the Methodists to sponsor the school, and then turned to the Baptists when the Methodists declined. The Baptists took control of Mississippi College in 1850. (Courtesy of MC.)

In 1888, in the aftermath of the Civil War and Reconstruction, Mississippi College's faculty consisted of only seven professors. Rev. Warren S. Webb is the white-bearded man; he was originally from New York. Webb was president of the college in 1888 and had served as pastor of the Clinton Baptist Church. The other faculty pictured are H. C. Timberlake, P. H. Eager, George Wharton, B. H. Whitfield (standing left), Tim K. Roby, and Mrs. R. A. Roby (seated left). Below, Calhoun County native and Mississippi College student John W. Provine (seated far right) would earn a doctorate in chemistry from a German university. Dr. Provine returned to his alma mater as a professor of science, and in 1911, he became president of Mississippi College. (Courtesy of MC.)

Alonzo C. Ball came to Mississippi College from rural Chickasaw County in the 1890s to study the ministry. Ball had only $12 in his pocket, but since age 15, he had felt a desire to preach as a Baptist minister. Ball joined the "frying-pan brigade" (students who cooked and cleaned to pay their tuition) at Nelson Cottage on campus, and this way he was able to meet his tuition and expenses. Ball graduated free of debt and took charge of a church in Arkansas. Reverend Ball is pictured here with his wife. Below is an early Mississippi College graduation around 1914, complete with minstrels. (Courtesy of MC.)

Provine Chapel is the oldest existing building on the college campus. The old chapel was built in 1860 at the cost of $25,780 and measures about 12,000 square feet. The belfry was removed sometime in the early 20th century and later placed between Chrestman and Lowrey Hall. According to a son of an old Mississippi College alumnus, one of the male rites of passage in the old days was for a student to be able to throw a baseball completely over the chapel roof (current MC students are not advised to try this). The chapel was used up until the 1940s, when the newer, larger Nelson Hall became available for service. Below is the last college assembly in Provine Chapel. (Courtesy of MC.)

The *Baptist Record* began inside a Clinton house in 1877. The Baptist journal served as a means of communication and discussion on Baptist issues within Mississippi. Today the *Baptist Record* has a circulation of 100,000, which makes it one of the most circulated journals in the state. Platus Iberus Lipsey was pastor of the Clinton Baptist Church from 1900 to 1912. After resigning the church pastorate, Reverend Lipsey served as editor of the *Baptist Record*, a position he held for 40 years. Below is the old College Hotel, which existed in Lipsey's day but has disappeared with time. The College Hotel was perhaps located on the south side of the campus. (Courtesy of MC.)

Ratliff Hall was built in 1913 and is named for Capt. W. T. Ratliff, Mississippi College's longtime president of the board of trustees. Ratliff Hall was called Home of the Self-Help Club because it offered affordable lodgings for students struggling to pay the $100 in yearly expenses. Students could board at Ratliff Hall for $6 per month and could pay their room and tuition by performing housekeeping, maintenance, and kitchen duties. Students in need of more financial assistance could work at the MC dairy south of campus. At first, the Self-Help Club was a success, accommodating 100 students, and Dr. Provine widened the program to accommodate 150. However, by 1919, the college was forced to sell the dairy farm because too few students wanted to stay and milk cows during the summer months. Below, MC students and faculty pose for a photograph at a nearby log cabin. (Courtesy of MC.)

MISSISSIPPI COLLEGE

FOUNDED IN 1826

STANDS FOR HIGHEST IN CHRISTIAN EDUCATION

STRONG FACULTY
IDEAL COLLEGE LOCATION

Owns Lighting System and Deep Well
of Pure Water

Expenses Moderate

ENROLLMENT OF 400 COLLEGE MEN
PRESENT SESSION

APPLY FOR CATALOG

J. W. PROVINE, Ph.D., LL.D.
PRESIDENT

CLINTON, MISSISSIPPI

This Mississippi College advertisement was printed in the 1920s, when the school proudly boasted of a "lighting system," a "deep well of pure water," and an enrollment of 400 students. Above all, the advertisement emphasizes the college's Christian affiliation which was then, as it is now, one of Mississippi College's major attractions for students. Below is another side of MC. Students dress in a variety of attires for their "White Mule" gathering. A mysterious beverage is being poured by the center student at 75¢ a gallon, and the sign on the mule says "don't park your car around 'us' at night." (Courtesy of MC.)

The above Jennings Hall was built in 1907 at the cost of $95,866 and measures about 20,000 square feet. The below Alumni Hall was built in 1926 at the cost of $137,013 and measures about 50,000 square feet. The building was constructed as a gymnasium for health and physical education and was considered at the time of its construction the finest such building in Mississippi. The original Mount Salus Church was located on the very grounds where the Alumni Hall now stands. (Courtesy of MC.)

Above is Bill Turner, known by MC students as "Uncle Bill," who delivered the mail for Mississippi College from 1867 until the early 1900s and was rather a fixture around the campus. Uncle Bill Turner also picked up students at the Clinton Depot and brought them to campus. (Courtesy of MC.)

MC students use their new means of transportation to transport themselves to a place never intended for it. The juxtaposition of this photograph with Uncle Bill Turner marks one of several silent transitions that have occurred in Mississippi College's history. (Courtesy of MC.)

While it is popularly believed that student bodies consisted of traditional students during the early 1900s, the above picture of MC "dear daddies" with their children belies this assertion. The comparative anatomy class below was comprehensive for students. Aside from the visibly large tortoise, students were required to examine the anatomy of a variety of mammals, reptiles, and amphibians. (Courtesy of MC.)

Above is the varsity Choctaw football team of 1907–1908. Before the era of pads, helmets, and tear-away jerseys, football was a virile, bruising sport. From left to right are (seated) Price, Smith, Lowrey, and Vanderberg; (kneeling) Rice, Brooks, G. L. Rice, and Canada; (standing) Jones, Carothers, and Cockerham. The football banquet below was hosted in the 1920s to honor the emerging tradition of Choctaw football. (Courtesy of MC.)

The Mississippi College marching band and its conductor prepare for a fall parade. Below is a big band not as big in size as the one above but every bit as big in sound. With two saxophones, one clarinet, one coronet, drums, a violin, and piano accompaniment, this band will not lack any swing. (Courtesy of MC.)

At left is Prof. Murry Latimer, who taught Greek and classics at Mississippi College. Professor Latimer came to Clinton and married Leura Myrtle Webb, the daughter Mississippi College president Dr. Warren S. Webb. Aside from his teaching duties at Mississippi College, Professor Latimer also served as Clinton's mayor from 1906 to 1919. Below is his junior colleague and eventual successor as mayor, Dr. Arthur Eugene Wood. Dr. Wood was the MC chairman of the chemistry department and mayor of Clinton from 1931 to 1957 and 1961 to 1968. (Courtesy of MC.)

The Latimer House is located on 401 West Madison and was built in the 1890s by Dr. Webb, president of Mississippi College from 1873 to 1891. Later his son-in-law, Professor Latimer, acquired the house and added a second-floor porch above the entrance. The house is surrounded with live oaks with resurrection moss, which add to the beauty of this Clinton home. Professor Latimer also kept cows and other livestock on the property. In 1969, the college purchased the Latimer estate and initially used the building for faculty housing. Later Mrs. Joy Nobles, wife of then-president Dr. Lewis Nobles, led the effort to renovate the Latimer House. (Courtesy of Robert Wall.)

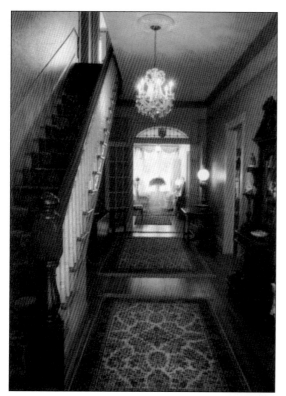

The Latimer House today is open for public viewing. Once a visitor opens the restored door and walks to the foyer, he or she is directly across from the sun porch. The antique chandelier once belonged to a home in Kennebunkport, Maine. Below, double French doors separate the sun porch from the foyer. The hardwood floors are covered with floral Belgian rugs that are made with three blends of wool. The wrought-iron floor lamp is original to the Latimer House. (Courtesy of Robert Wall.)

Most of the parlor furnishings are original to the Latimer House. The hand-knotted Polanaise rug was made in India from New Zealand wool. The upstairs guest bedroom in the Latimer House features several interesting items such as the rosewood half-tester bed. The Chinese hand-knotted rug is an Aubusson. (Courtesy of Robert Wall.)

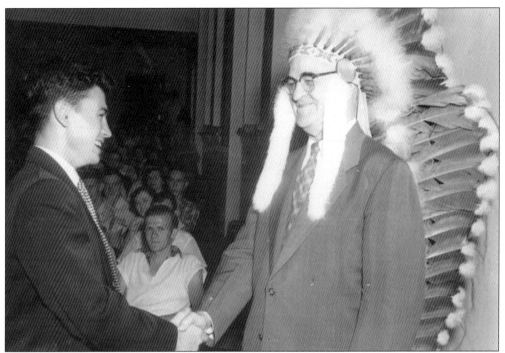

Mississippi College pays tribute to Dr. Dot M. Nelson by presenting him a Choctaw headpiece. Dr. Nelson graduated from Mississippi College in 1907 and worked as an assistant and later professor of chemistry and physics. Dr. Nelson was president of Mississippi College from 1932 to 1957. With an economic depression and a world war, these years were arguably the most difficult for the college since the Civil War. However, the Nelson administration was full of progress. In 1942, Dr. Nelson kept Mississippi College financially afloat by merging the school with Hillman College and applying to the U.S. War Department to receive a V12 naval officer training school. Both of these moves provided Mississippi College with new students while most of its male students were serving in the military. (Courtesy of MC.)

This aerial photograph from the northeast corner of Mississippi College shows the gradual westward progression of the campus. The date of the photograph is uncertain, but it predates the construction of the A. E. Wood Coliseum. (Courtesy of MC.)

The 1967 Mississippi College Commencement was in honor of Dr. D. M. Nelson's presidency. During his long tenure, Dr. Nelson had been in the vanguard of change at the college. (Courtesy of MC.)

Dr. Walter Hillman was a professor at Mississippi College before becoming the longtime president of Central Female Institute (CFI) in 1857. CFI was later renamed Hillman College in honor of Dr. Hillman and his wife, Adelia, who served as a professor at the school. The Hillmans were from the North, and according to one story, they were able to dissuade General Sherman from immolating Clinton's two colleges during the Union occupation. After the war, Mississippi College was almost financially ruined, and the MC Board of Trustees asked Hillman to serve as the president of both CFI and MC. Hillman's tireless efforts undoubtedly saved MC from closing, and soon both colleges were debt free. Dr. Hillman also served as pastor of the Baptist church during the Civil War. While Dr. Hillman was popular among Clintonians, he never forgot his Northern roots and was supportive of another Northerner, Sarah Dickey, when she came to Clinton to open Mount Hermon Seminary for freed women. Next to Walter Leake, there is perhaps no one more indispensable to Clinton's past or present than Walter Hillman. (Courtesy of MC.)

Central Female Institute was founded in 1853 by the Central Baptist Association and was administered by Dr. Walter Hillman, a former MC professor and minister at the Clinton Baptist Church. The institute was later renamed Hillman College in honor of its first president. The buildings in this photograph were once located in what is now Lyons Park in Clinton and housed the students at Hillman College. In 1945, Hillman College was bought by Mississippi College. The photograph below is the Hillman Art Gallery, where there was no shortage of artistic talent. (Courtesy of MC.)

Dr. Walter Hillman and his wife, Mrs. Adelia Hillman, are seated in this picture of the faculty, student body, and staff of Central Female Institute. Dr. Hillman served as the president of CFI for 37 years. After the death of Dr. Hillman in 1894, Mrs. Hillman succeeded her husband as president of the institute and served for two years. In 1891, the board of trustees changed the school's name to Hillman College in honor of both husband and wife. (Courtesy of MC.)

HAPPY, HOME-LIKE
HILLMAN

A JUNIOR COLLEGE FOR
YOUNG LADIES

Located at the very throbbing heart of Mississippi, nine miles from the State Capital, in a cultured, classic little town which is famous for its school, its fine moral and religious influences and its healthfulness.

Hillman offers exceptionally good advantages in Piano, Voice, Expression and Literary Work. Prices moderate. Accommodations only for 100, making individual care the most desirable. Wholesome physical, social, intellectual and moral life. Graduates of approved schools enter Junior Class without examination. HILLMAN graduates get State License to Teach. A School Where Girls are Safe and Happy.

HILLMAN COLLEGE
CLINTON, MISS.

This 1920s advertisement of Hillman College outlines the attitudes and fields of study that were deemed important for the education of a Southern lady. (Courtesy of MC.)

Dr. William Tyndale Lowrey served as MC president from 1898 to 1911 and became president of Hillman in 1906. During Dr. Lowrey's administration, Hillman was modernized: steam pipes took the place of stove heating, electric lights the place of oil lamps, and the campus property was enlarged so the students could have tennis and basketball courts. In 1911, Dr. Lowrey became president of Blue Mountain College and was forced to split his time between the two colleges. However, Dr. Lowrey was assisted at Hillman by his nephew, Prof. L. T. Lowrey. Below, L. T. Lowrey casts aside his important duties as professor and vice president to model for a Hillman College art class. (Courtesy of MC.)

One of Dr. Lowrey's most important additions to Hillman College was the Industrial Home. Students who wanted to lessen their tuition and college expenses could live and work in the Industrial Home. In 1913, the administrator of the Industrial Home was Mamie Elizabeth Kethley (right), and one of her duties to Hillman was making the white dresses that Hillman students often wore. Possibly one of the duties of the students living in the Industrial Home was to make the dresses we will see in the following pages. (Courtesy of MC.)

1914

From left to right, Hillman College students Mary Lea, Mittie Fortinberry, Polka McIntyre, Gwynneth Dunn, Annie Ramseay Longino, and Edith Mathis pose in their long, formal white dresses. While Hillman students might be given a man's privilege—education—these women were still expected to be the quintessence of grace and sophistication. However, as the below photograph infers, a Hillman girl could be daring and dainty simultaneously. (Courtesy of MC.)

Senior artists Ruth McCaughan (left), Zilphia Odom (center), and Eula Cupit work on their final paintings. As a memento to art, the three leave this: "The Seniors' last pictures are painted / And the tubes are twisted and dried, / From exhaustion we've almost fainted/ And it seems that ambition has died. / For awhile we shall rest as we need it, / Let down for an hour or two/ Till the love for Art as we feel it, / Shall set us to working anew." (Courtesy of MC.)

Students Linda Mae Bridges, Margaret Lewis, Mary White, and Mamie Adams practice hard in Mabel Wilcox's second-year harmony class. Miss Wilcox, at the piano, was described in a yearbook as a "bewitching, dark-eyed Yankee [who] hails from the state of New York" who was serious about music. Often Miss Wilcox told her students "there is no royal road to music" and music "is a practice as full of labor as a wise man's art." (Courtesy of MC.)

1914

From left to right, Hillman College students Gwynneth Dunn, Ruth Birdsong, Rust Martin, Ruth White, Polka McIntyre, Christine Caldwell, and Lena Nelson drink Cokes and enjoy a leisurely drive, stopping momentarily for this picture in front of the Johnston House on Leake Street near downtown Clinton. Behind them, a black spectator stands near a tree. (Courtesy of Robert Wall.)

1917

While Hillman College students were expected to display all the qualities of grace and sophistication, they were also allowed to have fun. Louisiana students in particular felt obliged to reveal a more fun and carefree attitude towards their college environment. Perhaps this was to honor the characterization bestowed on them by their Mississippi classmates! Dorothy Simmons (left) and Lucile Lowery smile wide and say to us, "Don't sour on the world!" (Courtesy of Robert Wall.)

Sarah Dickey was born in 1838 near Dayton, Ohio. She moved to Mississippi after the Civil War to educate freed slaves. Although Dickey was hardly encouraged to receive an education, she learned to read and write and attended Mount Holyoke Seminary in Massachusetts. During her time at Mount Holyoke, Dickey inherited a desire to teach others. In 1871, Dickey moved to Clinton, and in 1873, she was granted a charter for Mount Hermon Female Seminary for black women, which opened in 1875. Dickey worked until her death in 1904 to ensure than African American women could be educated. While her accomplishments were phenomenal for her time, Dickey refused to wear them proudly on her chest, saying, "I do not boast. Many a one in my place would have accomplished more, but I am so thankful my Heavenly Father has honored me with a little work to do, as best I can, in His vineyard." (Courtesy of Debbie Tillman.)

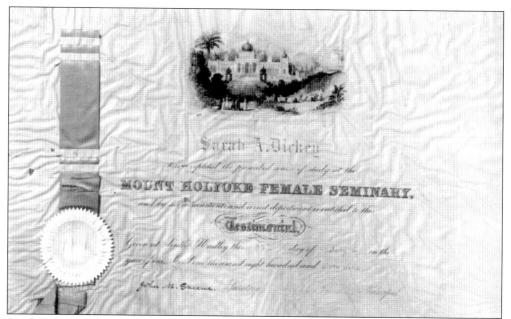

Sarah Dickey wanted to be a teacher when she was 16. However, while Dickey could read and spell words, she could not write. Dickey's family tried to discourage her from seeking an education, but she lent herself out to a neighboring family who helped her learn to write, and around 1865, Dickey was ready to enroll at Mount Holyoke Female Seminary (now Mount Holyoke College), where she graduated in 1869. (Courtesy of Debbie Tillman.)

After her graduation, Dickey wrote to a friend that she wanted to establish "a Mt. Holyoke Seminary for colored girls," and in 1871, that is what she did. Mount Hermon operated as a work-study institution for 28 years and averaged about 100 students per session. The school was located in what is now western Clinton near Sumner Hill. (Courtesy of Debbie Tillman.)

Three

A MODERN
SUBURBAN CENTER

World War II was the event that did more to change Clinton than perhaps the Civil War itself. Several of Clinton's finest citizens, such as Dr. E. D. Reynolds, became leaders in the military. Other individuals, such as Ed McDonald, came to Clinton to enroll in the navy V12 officer training program at Mississippi College and later settled in the area. Clinton also housed about 3,000 German POWs at Camp Clinton. However, after the war, its effects continued to ripple for Clinton. In 1940, Clinton had a population of 916, and no property had been added to the town for almost 100 years. From 1940 to 1960, Clinton's population increased to 3,438, and the city's population doubled in both the 1970 and 1980 censuses. If the antebellum period was Clinton's boom, then the 1950s and 1960s was its bang. Postwar growth transformed Clinton from a small, independent community and college town into a modern suburban center. The first reason for this growth was that veterans such as war hero Carey Ashcraft and his family decided to make Clinton their new home. Secondly, as Jackson grew into a modern city with all the benefits and problems that accompanies growth, Clinton's future was also ineluctably changed. Clinton's independent sense of community began to be marked through its schools, businesses, and neighborhoods.

The modern-day descendants of Gov. Walter Leake gather on a Sunday afternoon to discuss events happening in the community and around the world. In the years before World War II, the Johnstons and the Ashfords often met in the backyard of what is today known as the Landrum House at 207 West Main Street. From left to right are Martha Ashford, daughter Mary Beth, Hartwell T. Ashford Jr., young Lyda Johnston, Edith Ashford Johnston, cousin Mary Francis Wyatt, Lida Hooker Johnston, young Edith Johnston, her first cousin Martha Francis Ashford, Martha Tyrone Ashford, and A. W. Ashford. (Courtesy of Lyda Gilmore.)

Dr. Ernest Darden Reynolds had just moved his practice and small family to Clinton when the United States entered World War II. Dr. Reynolds was 30 years old when he was called to active duty in May 1942. He is pictured here with his daughter Isabell outside his home in Clinton about two hours before he left for training at San Antonio, Texas. Dr. Reynolds was assigned to the 118th Medical Battalion, 43rd Division. (Courtesy of Reynolds family.)

Lieutenant Reynolds and the 118th were assigned to New Georgia in the Solomon Islands. Reynolds was eventually promoted to major and was chief of surgery in a forward hospital. Major Reynolds performed 50 major surgeries with a zero mortality rate, usually working in a tent "containing four operating tables and two operating lights," according to a newspaper clipping. One operation was interrupted by a Japanese air raid that damaged the surgical tent and injured Major Reynolds. Despite his injuries, Dr. Reynolds completed the surgery before tending to his wounds. (Courtesy of Reynolds family.)

As the United States mobilized militarily for World War II, the armed forces realized that they would need a larger officer program in order to train larger amounts of officers to command the massive armies that were assembling across the country. Mississippi College was one of 1,600 institutions that applied for a navy V12 program and one of the 131 institutions that were selected nationwide. (Courtesy of MC.)

The first term for the V12 unit began in July 1, 1943. Enrollment for that first term was 335 men, and the navy unit was given full use of Chrestman dormitory, Alumni Hall, and the main cafeteria. The trainees were required to complete at least 17 hours per semester and to participate in daily exercises and drills. Around this time, Mississippi College had also merged with Hillman, but the coeds lived and ate on the old Hillman campus. (Courtesy of MC.)

Both of Mississippi College's physical-education instructors had joined the military in 1943. However, the navy had its own rigorous training program, and any civilian students who wanted to exercise with the navy trainees could do so. Here men from the V12 unit participate in boxing class, possibly with some civilian students. (Courtesy of MC.)

Dr. Dot Nelson and various navy brass oversee a V12 drill on the old football/soccer field. In March 1945, Dr. Nelson reported that 61 percent of Mississippi College's income came from the Department of the Navy. The Navy V12 unit provided the funds to help the college survive the war years, when male students were scarce, and the faculty was better prepared to instruct a new generation of students who came to MC on the G.I. Bill. (Courtesy of MC.)

Ed McDonald was a native of Meridian, Mississippi, when World War II began and came to Clinton when he was 18 as a navy V12 trainee. Ed McDonald also worked as a fireman at Camp Clinton. Here Ed and Mary, his future wife, spend a romantic moment away at Lake Wilson, which at one time was located where the present Winn-Dixie building is today. (Courtesy of Ed McDonald.)

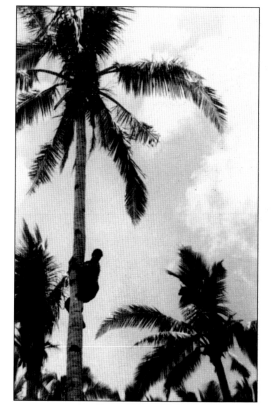

On Samar Island in the Philippines, Ed McDonald takes a break and climbs extremely high for a coconut. McDonald was commissioned a pharmacist mate second class and assigned to a malaria control unit. His unit was based out of Bethesda, Maryland, and was ordered to the Pacific theater to research ways of safeguarding American soldiers from malaria. McDonald's unit was attached to different units in the Pacific, so he could be sweating in the South Pacific one day and freezing in northern China the next. (Courtesy of Ed McDonald.)

When the United States entered World War II, Carey Ashcraft was a student and a member of the Reserve Officers Training Corps (ROTC) at Mississippi State University (MSU). During the summer of 1942, all West Point and ROTC cadets were ordered to accelerate their academic courses. Ashcraft graduated from MSU in January 1943, and one month later, he reported to Officer Candidate School (OCS) at Fort Benning, Georgia. After OCS, Lieutenant Ashcraft was assigned to Cannon Company, 350th Infantry, 88th Division. (Courtesy of Carey Ashcraft.)

Carey Ashcraft entered combat at Minturno, Italy, in March 1944, was assigned as a forward observer, and was captured by the Germans north of Florence on September 21, 1944. Ashcraft was sent to a German POW camp. In early 1945, fearing that Hitler had ordered all Allied POWs shot before rescue, Ashcraft and other POWs escaped but were recaptured. They were finally liberated on April 29, 1945. Ashcraft received the Bronze Star and Purple Heart. (Courtesy of Carey Ashcraft.)

During World War II, there were four prisoner of war camps in Mississippi, and one was Camp Clinton off McRaven Road. Camp Clinton was used as an internment place for German soldiers captured in the North African desert and other places. Most of the POWs came from Field Marshal Erwin Rommel's Afrika Korps. Among Camp Clinton's residents were the most important officers in the German army. From 1939 to 1945, of the 40 German generals captured by Allied forces, 35 of them were detained at Camp Clinton. Some of the more high-profile prisoners included Gen. Jurgen Von Arnim, Rommel's replacement, and Count Christoph Stolberg, a brigadier general. (Courtesy of MDAH.)

American forces launched Operation Torch, an amphibious landing on the Western African coast, in November 1942. Eventually American troops from the west and British forces from the east closed in on an outnumbered force of German and Italian soldiers in Libya and Tunisia, and about 275,000 Axis forces surrendered to the Allies. The American government realized the potential benefit of bringing the POWs to the United States, but first they had to construct the prisons and assemble the manpower to control them. The German prisoners were housed in barracks that could hold 50 men, and every fifth barracks had a kitchen and mess hall. Often German cooks prepared the food using American stock and ingredients, and often the POWs enjoyed these meals. The Geneva Convention mandates that prisoners receive food, clothing, and medical attention equal to that of their captors. (Courtesy of MDAH.)

German POWs were paid 80¢ a day for their labor. The Geneva Convention disapproved of forcing prisoners to be involved in efforts that could benefit the military objectives of their captors, so the POWs worked to help the labor-short economy of wartime Mississippi. Most of the POWs picked cotton, filling heavy canvas sacks with cotton and removing the bolls by hand. Most German prisoners preferred clearing timber and pulpwood and planting sapling trees to picking cotton by hand. (Courtesy of MDAH.)

During World War II, Maj. Gen. Eugene Reybold was chief of the Army Corps of Engineers. General Reybold used German POW labor from Camp Clinton to clear one square mile outside of Jackson. After clearing the land, the POWs helped the corps build drainage ditches and miniature streets and cities, and eventually molded this into a large model of the entire Mississippi River basin. The purpose of this model is to help engineers predict floods and assess the flow of water from the Mississippi River and its tributaries. The basin miniature was the most important and ambitious project performed by the POWs at Camp Clinton. (Courtesy of CVC.)

After the war, Dr. Ernest Reynolds (above) returned to a successful practice in Clinton, and he was one of only two doctors between Clinton and Vicksburg. Dr. Reynolds delivered 2,000 babies during his 49-year practice; sometimes he accepted farm commodities instead of cash for payment. Ed McDonald returned to Clinton, married his sweetheart Mary Carr, and started his successful real estate business, which eventually grew into McDonald Realty. McDonald was also a candidate for mayor in 1969 and a charter member of Morrison Heights. Carey Ashcraft married his sweetheart Delva Blackwell and they moved their family to Clinton in the early 1960s. Ashcraft worked for the Mississippi Employment Security Commission for 40 years and eventually retired from the National Guard at the rank of lieutenant colonel. However, some brave Clintonians such as Lt. George Morehead (below) made the ultimate sacrifice for American freedom. (Courtesy of Reynolds family and Robert Wall.)

Clinton was never the same after World War II, but despite its growth and population influx, the town settled into a new sort of normalcy in the 1950s that was similar to the old. In the late 1950s, Allen Ray McEarley (one of the men who rode in Charles Lindbergh's biplane in 1926) was worthy patron of the Clinton Freemason Lodge. His wife, Edyce Myrick McEarley, is on the right edge of the pyramid, standing in the second row. Allen McEarley stands at the top of the pyramid and his head is directly under the Eastern Star. While McEarley is an old Clintonian (a direct descendant of Baldwin Thomas), many in this photograph are new Clintonians. Seated front and center are Ed and Mary McDonald. Behind Mrs. McDonald is her father, J. M. Carr. Mary McDonald was chosen to be worthy matron, and Ed McDonald was chosen to be international head of the Eastern Star. (Courtesy of Ed McDonald.)

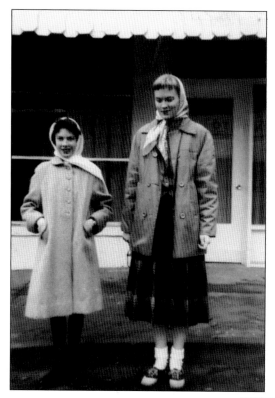

Edith (right) and Lyda Johnston, daughters of store owner Robert H. Johnston II and Edith Ashford Johnston, stand in front of what was the Struthers Grocery store across from what was then the Western Auto sometime in the 1950s. Around this time, their uncle, H. T. Ashford, son of Dr. Ashford, opened the Hilltop Theatre in Clinton. Before the Hilltop, Clinton moviegoers had to drive to Jackson to watch a show on the silver screen. Not everyone in Clinton appreciated having a movie theater in their town, but for others, the Hilltop provided entertainment that was exciting and economical. (Courtesy of Lyda Gilmore.)

This Hilltop show schedule for March 1963 shows that the price for a movie was 45¢ for an adult and 25¢ for a child under 12. The picture started at 6:30 every night, and the Hilltop had a grill where viewers could purchase all sorts of good food. Some of the pictures the Hilltop showed in the month of March were *The Phantom of the Opera*, *Seven Brides for Seven Brothers*, and *The Adventures of Huckleberry Finn*. Some of the actor names that are printed here are James Stewart and Jackie Gleason. Generations of young Clintonians were probably introduced to stars such as John Wayne, Marilyn Monroe, and Marlon Brando at the Hilltop. (Courtesy of Lyda Gilmore.)

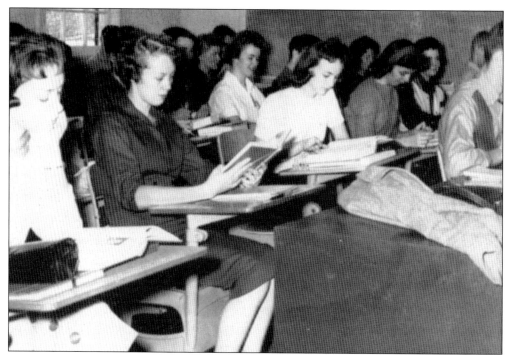

Clinton High School (CHS) in the 1950s and 1960s was 7th through 12th grade and was located on College Street where the old junior high buildings are today. One of the most important classes for a CHS senior wanting to graduate was senior English. Here students would probe deeply into Chaucer, Shakespeare, and Donne to earn their graduating credits. (Courtesy of Clinton Public Schools [CPS].)

Doug Hutton (kneeling second from right) was a member of this 1960 Clinton basketball team who did not face the camera. Hutton graduated from Clinton in 1960 and earned an athletic scholarship from Mississippi State University. In 1963, the MSU Bulldogs were invited to play in the NCAA tournament against Loyola University. The problem was Loyola, a Chicago school, had an integrated team, and Hutton and his teammates faced arrest if they chose to play. The Bulldogs snuck out of town, and a racial barrier was broken. (Courtesy of CPS.)

Today the state government has a paid lunch system for families who qualify for assistance based on income. However, in the 1950s and 1960s, a school lunch cost under $1, and any CHS student who wanted a lunch for free could earn it by working as a cafeteria server during the lunch period. Each student would work a different lunch shift, eat, and return to class. (Courtesy of CPS.)

During the 1950s and 1960s, responsible students at CHS had many opportunities, and some of the Clinton seniors were hired as bus drivers. Obviously these young men had to be early risers to run their route, and they had to be safe drivers as well. Student responsibility, it was believed in the public schools then, made for responsible adults and citizens. (Courtesy of CPS.)

Acclaimed writer and Clinton native Barry Hannah signs a copy of one of his books during the Dewitt Clinton Celebration in April 1984 at the A. E. Wood Memorial Library. The event was Hannah's first speaking engagement in his hometown. In 1972, Hannah won the William Faulkner Prize for writing and was nominated for the National Book Award for his novel *Geronimo Rex.* The novel is set in a fictional community, Dream of Pines, Louisiana, which most critics believe is Clinton, and the novel is based on Hannah's experiences as a youth in Clinton. (Courtesy of Charlene McCord.)

Barry Hannah speaks to literary fans at the A. E. Wood Memorial Library in Clinton. Aside from *Geronimo Rex*, Hannah has a body of work including novellas such as *Ray* and story collections such as *Airships*, which helped Hannah earn the Award for Literature from the American Institute of Arts and Letters. Hannah has also been nominated for the Pulitzer Prize. Hannah's success as a writer has earned him the coveted position of writer in residence at Ole Miss. (Courtesy of Charlene McCord.)

Scholars of Southern literature consider Barry Hannah one of Mississippi's greatest writers, and fans are intrigued by Hannah's "wild man" image. However, this portrait of the artist as a young man reminds us that Hannah at CHS most distinguished himself not for his writing but for his musical skills. In 1960, Hannah was first-chair coronet and was voted most talented by his classmates. Women classmates recall that Hannah was considered very handsome and popular at CHS. (Courtesy of CPS.)

Barry Hannah learns from CHS band director Richard Prenshaw. In his story "Testimony of Pilot" in the *Airships* collection, the narrator recounts his memories of playing in the high school band with his friends. Music is a powerful force in many of Hannah's stories, and some scholars feel that Hannah's prose has a rhythmic aura. (Courtesy of CPS.)

Wyatt Waters was in the 10th grade when his family moved to Clinton. He received bachelor's and master's degrees in art from Mississippi College. After graduation, Waters chose to use Clinton and other Deep South locations as settings for his art. Waters and his wife, Vicki, operate a studio on Jefferson Street where the Clinton artist displays his work and engages in discussions on any topic under the sun. Waters's gallery is one of the hubs of Clinton's intellectual life. (Courtesy of Wyatt Waters.)

Wyatt Waters prefers working on location. Here is a watercolor depiction of Jefferson Street; the artist's eye is facing south towards Mississippi College. For private portraits, Waters once charged $7.50 a sitting. Today his paintings sell for about $750 to $2,000. Waters has authored books such as *An Oxford Sketchbook*, *Wyatt Waters: Painting Home*, and his work has been featured in *Art and Antiques*, *American Artist*, *Watercolor*, and *Mississippi Magazine*. (Courtesy of Wyatt Waters.)

The Potter House is located on West Leake Street and was built in the 1870s. Once the home of Nell Potter, today the Potter House is home to Gravity Coffeehouse, operated by the Courson family. Gravity is within walking distance of Wyatt Waters's gallery, and the Coursons offer their walls to the paintings of aspiring artists. On Sunday afternoons, Pastor Gary Davis leads his Crossings Church congregation in prayer, songs, and frothy cappuccinos at Gravity. (Courtesy of Courson family.)

On July 4, 1976, the United States celebrated its 200th birthday with festivities in almost every American town and city. The beginning of the 1976 bicentennial celebration started at noon in Clinton with the ringing of the bell in the old chapel belfry. The ceremony coordinator was Clinton councilman Walter Howell, the future mayor, and he and his son Michael rang the bell and began Clinton's bicentennial celebration. (Courtesy of Walter Howell.)

Dressed in the costumes of American patriots, (from left to right) Paul Howell, Charles Farmer Jr., Clinton Junior High School social studies teacher Pauline Akers, and Darrell Dilmore pose outside city hall during the 1976 bicentennial celebration. (Courtesy of Walter Howell.)

Clintonians stroll down the brick streets of Olde Towne during the 1976 bicentennial. In November 1929, an African American man was hired by the city to lay approximately 614,000 red bricks along Jefferson, West Leake, New Prospect, and Monroe Streets. The bricks cost $460.95 total and the labor $463.57. Monroe and New Prospect were paved over in recent years, but Jefferson and West Leake Streets remain a Clinton showpiece. Every year, the Arts and Crafts and Brick Street Festivals are held on Clinton's bricks. (Courtesy of Robert Wall.)

The CHS Homecoming Parade is one of the most celebrated events in all of Clinton. Aside from the numerous high school clubs and organizations, all sorts of groups participate in the CHS Homecoming Parade. One of the author's most vivid memories is marching in the parade first as a Boy Scout and later as a member of the CHS marching band. (Courtesy of Robert Wall.)

In September 1980, the Attaché Show Choir was formed at CHS by Winona Costello. While Clinton had a concert choir, the Attaché Choir was to be a performance choir. The singers would sing and dance in a Broadway musical style. The first Attaché Choir had about 62 members, which made it one of the largest show choirs in the South. Twenty-six years later, Attaché is the undisputed showpiece for modern Clinton. (Courtesy of David and Mary Fehr.)

The Attaché Show Choir performs at the French Quarter in New Orleans sometime in the early 1980s. In contest after contest, year after year, Attaché continues to bring home the gold, earning it (and Clinton) national renown. (Courtesy of David and Mary Fehr.)

BIBLIOGRAPHY

Aikens, Nolan, Alice Hobson, Jan Hurt, and John Murphy. "Clinton—History and Progress: A Curriculum Unit for Middle-School Social Studies." Unpublished Clinton Junior High curricula, 1992–1993.

American Association of University Women, Clinton-Raymond branch. *Down Brick Streets: A Guide to Historical Sites in Clinton, Mississippi.* Bicentennial project of AAUW, 1976.

Ashcraft, Carey E. "Country Boy Infantry: 'The Blue Devils,' 88th Infantry Division: 1944–1945." Printed manuscript, 1996.

Brough, Charles Hillman. "Historic Clinton." *Publications of the Mississippi Historical Society,* vol. 7 (1903): 281–316.

Cardin, Tommy, Lydia Jones, Paul Mucho, and Ed Smith. "Restoration of the Sarah Dickey Grave Site: 1995/96 Leadership Clinton Team Project Report." Unpublished report on Dickey and Odd Fellows cemeteries, 1995–1996.

Faucette, Shirley. "Clinton Yesterday." *Journal of Mississippi History* 40.1 (1978).

Gough, Norman. "Mississippi College Historical Spots." Unpublished listing, *c.* 1995.

Griffith, Helen. *Dauntless in Mississippi.* South Hadley, MA: Dinosaur Press, 1965.

Martin, Charles E. "Clinton: The Athens of Mississippi." Clinton, MS: Friends of the Clinton Library, A. E. Wood Memorial Library, 1999.

———. *A Heritage to Cherish: A History of First Baptist Church, Clinton, Mississippi, 1852–2002.* Nashville: Fields Publishing, 2001.

———. "Mississippi College: From a Frontier Academy to Modern University." *The Clinton News,* January 6, 2000.

———. "The Navy V12 Unit at Mississippi College." Unpublished article, 2000.

McIntire, Carl. "Mt. Salus Presbyterian Church Anniversary Set." *The Clarion Ledger,* February 28, 1982: 4G.

Sansing, David G. "Walter Leake: Third Governor of Mississippi: 1822–1825." *Mississippi History Now* (2003). The Mississippi Historical Society. December 2003. http://mshistory.k12.ms.us/features/feature47/governors/3_walter_leake.htm

Skates, John Ray. "German Prisoners of War in Mississippi, 1943-1946." *Mississippi History Now* (2001). The Mississippi Historical Society. September 2001. http://mshistory.k12.ms.us/features/feature20/germanprisonersofwar.html.

Smith, Charles. "Hilltop Cemetery." *The Clinton News.*

———. "Lindbergh Visited Clinton Before Famous Paris Flight." *The Clinton News* 32.41, October 8, 1981.

United Daughters of the Confederacy. "Clinton and the Civil War." Printed manuscript, 1916.

ACROSS AMERICA, PEOPLE ARE DISCOVERING SOMETHING WONDERFUL. *THEIR HERITAGE.*

Arcadia Publishing is the leading local history publisher in the United States. With more than 3,000 titles in print and hundreds of new titles released every year, Arcadia has extensive specialized experience chronicling the history of communities and celebrating America's hidden stories, bringing to life the people, places, and events from the past. To discover the history of other communities across the nation, please visit:

www.arcadiapublishing.com

Customized search tools allow you to find regional history books about the town where you grew up, the cities where your friends and family live, the town where your parents met, or even that retirement spot you've been dreaming about.

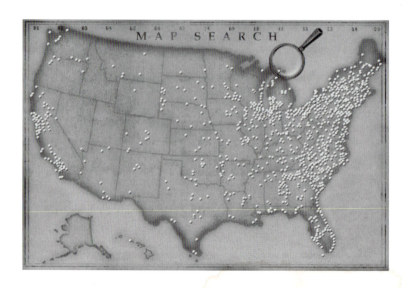